A Kid's Guide to Drawing™

How to Draw
Christmas Symbols

Christine Webster

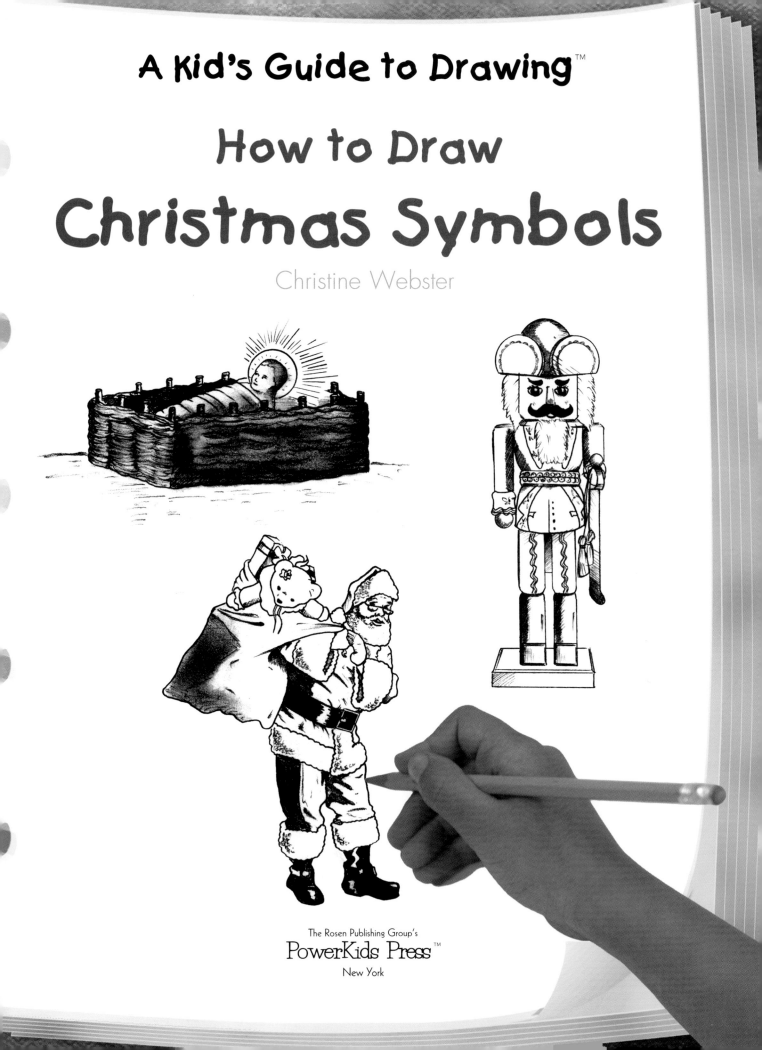

The Rosen Publishing Group's
PowerKids Press™
New York

To my children for making Christmas so much fun:
Jacob, Arianna, Griffin, and Oliver

Published in 2005 by The Rosen Publishing Group, Inc.
29 East 21st Street, New York, NY 10010

First Edition

Editor: Orli Zuravicky
Book Design: Kim Sonsky
Layout Design: Mike Donnellan

Illustration Credits: Jamie Grecco
Photo Credits: Title page (hand) by Thaddeus Harden; p. 6 © Philadelphia Museum of Art/CORBIS; p. 8 © Steve Chenn/CORBIS; p. 10 © Michael Boys/CORBIS; pp. 12, 14, 16, 18 © Royalty-Free/CORBIS; p. 20 © Mark M. Lawrence.

Library of Congress Cataloging-in-Publication Data

Webster, Christine.
How to draw Christmas symbols / Christine Webster.
 p. cm. — (A Kid's guide to drawing)
Summary: Provides facts about eight symbols of the Christmas season, as well as step-by-step instructions for drawing each one. Includes bibliographical references and index.
ISBN 1-4042-2725-3 (library binding)
1. Christmas in art—Juvenile literature. 2. Drawing—Technique—Juvenile literature. [1. Christmas in art. 2. Drawing-Technique.] I. Title. II. Series.

NC825.C49W43 2005
743'.893942663—dc22

 2003015458

Manufactured in the United States of America

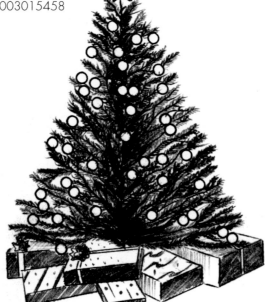

CONTENTS

Christmas Symbols

Imagine Christmas without baby Jesus, Santa Claus, or even a Christmas tree! It is hard to do. This is because these Christmas **symbols** are an important part of the Christmas season. Did you know that each Christmas symbol has a rich history behind it? Today's Christmas **celebration** is a combination of different **customs** and beliefs, some of which are thousands of years old. They came from many different places in the world. Some are based on real stories. Others are based on **legends**. Despite their different histories, all of these symbols come together to make up the celebration of Christmas.

Christmas is a very important holiday for Christians. Christians are people who follow the teachings of Jesus Christ. Jesus was a great **religious** teacher who lived a long time ago. When he died, his followers began a new religion called Christianity based on his teachings. Today there are more than two **billion** Christians in the world! Christians believe that Jesus is the Son of God, and Christmas marks the celebration of his birth.

Christians celebrate by going to church, feasting, and giving one another presents.

In this book, you will learn how to draw the most familiar Christmas symbols. You will also learn a little about the history and customs behind these symbols. Every drawing has directions under each step to help guide you. Each new step is marked in red. Be creative and add your own special touch. Be sure to check out the drawing shapes and terms on page 22. Take your time and have fun drawing your own Christmas symbols!

The supplies you will need to draw each Christmas symbol are:
- A sketch pad
- A number 2 pencil
- A pencil sharpener
- An eraser

Baby Jesus

Christians believe that thousands of years ago, an angel appeared before a young woman, Mary, and told her that she was going to give birth to God's son. She was to name him Jesus. One night Mary and her husband, Joseph, went to Bethlehem. They spent the night in a stable, where she gave birth to Jesus. Three wise men came to see him and brought him gifts.

The **nativity** scene shows baby Jesus in a **manger** at the stable in Bethlehem. Usually Mary, Joseph, and the three wise men are shown there, too. To celebrate Jesus's birth, today people **reenact** the nativity scene in plays and put plastic models of baby Jesus in the manger on their lawns during the Christmas season.

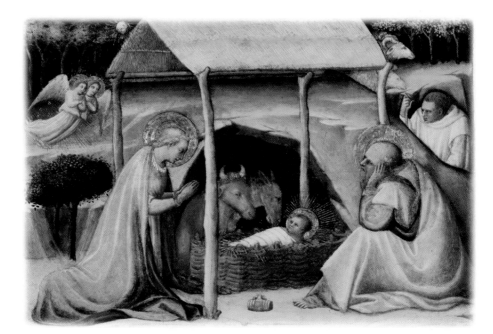

1

Start by drawing two rectangular shapes for the manger. Draw them lightly because we will erase them later.

2

Draw two circles for Jesus's head and halo. A halo is a circle of light.

3

Draw two angled sides for the body. Then draw straight lines for the back and the side of the manger.

4

Draw lines to form small rectangles around the top of the manger for the wooden beams.

5

Use the guidelines to soften the manger with wavy lines. Add curved lines to his body and to the top of each wooden beam. Erase any extra lines.

6

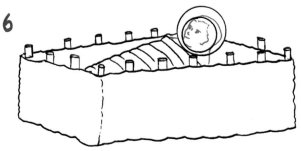

Draw his shoulders, face, hair, and back using the circle as a guide. Erase extra lines.

7

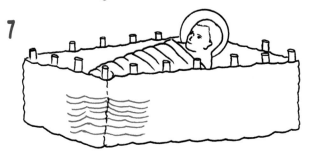

Draw some wavy lines to create the threading of the straw manger.

8

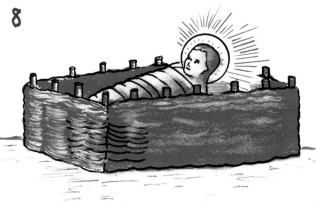

Great! Now finish the rest of the drawing and shade as shown.

Christmas Presents

Gift giving is an exciting part of Christmas. Some believe that this **tradition** began with the gifts of gold, **frankincense**, and **myrrh** that the wise men gave baby Jesus. Gold **represented** Jesus's future as the king of his people. Frankincense represented his role as a religious leader. Myrrh stood for his human nature.

Some believe gift giving began with Saint Nicholas, who was known for giving gifts and money to the poor. In his honor, people began to give each other gifts on his **feast day** in December. **Immigrants** brought the story of Saint Nicholas, or Santa Claus, to America. Today giving and receiving presents are a big part of the Christmas celebration.

1

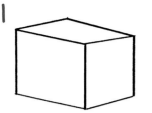

For the first present, draw a cube. A cube is an object with six square sides.

2

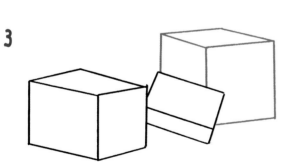

Draw a rectangle for the second present. Notice how the bottom left corner of the rectangle is hidden. Draw a straight line across the bottom of the shape.

3

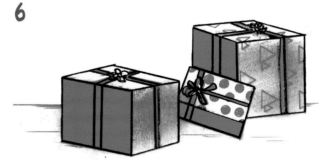

Draw another cube as shown, to form the third present. Notice how the bottom left side of the cube is hidden by the second present.

4

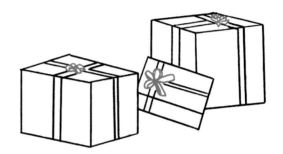

Good job! Now draw straight lines across each of the three boxes, as shown, for the ribbons. Notice how close together the lines are and where they meet at the top of each box.

5

Draw bows on top of each box, at the place where the ribbon lines meet. Make as many loops as you want for each bow. Erase any extra lines.

6

Now be creative! Add whatever shading or shapes you want to the wrapping paper to create the perfect Christmas presents!

The Christmas Stocking

Present-filled stockings hanging by the fire are a common Christmas tradition that began in the 1800s. According to a legend, Saint Nicholas was walking through a small village one day. There he heard of a poor **widower** whose three daughters could not marry because they had no **dowry**. Nicholas wanted to help. One night he secretly dropped a bag of gold down their chimney, where the daughters had hung their wet stockings to dry. The girls awoke to find gold in their stockings. They would be able to marry after all! The village people hung their own stockings up, hoping to find gold. Today hanging stockings by the fire to have them secretly filled with treats makes Christmas special for all.

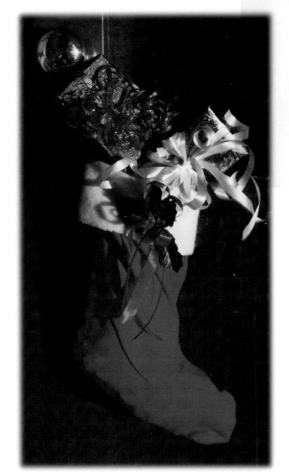

1

Begin by drawing two rectangular shapes as shown. The bottom one should be longer than the top one. Notice the position of the shapes.

2

Add a third rectangle to the bottom one for the foot of the stocking. It should be tilted, too, so that it sticks out to the right.

3

Now draw over the outer lines of the shapes, softening them so that the stocking looks fluffy.

4

Erase the extra lines from the original shapes.

5

Now draw two more rectangular shapes sticking out of the top of the stocking for the gifts.

6

That looks great! Now use shading to decorate the stocking and the presents. You can even write your name on the stocking!

Logan

Santa Claus

Today's Santa Claus is a fat, cheery, white-bearded man who wears a red and white suit and drives a **sleigh**. The original Santa was Saint Nicholas, the same man who began the stocking and gift-giving traditions! Nicholas was often seen in a red and white robe, riding his donkey through town and handing out presents to children. Dutch settlers brought the legend of Saint Nicholas, or Sinterklaas, to America. Soon he became an important part of Christmas in America. By 1773, "Sinterklaas" became "Santa Claus." In 1823, the children's story told in "'Twas the Night Before Christmas" added to the story of Santa. Some people say that Santa still lives at the **North Pole**. Elves help him make toys, which he **delivers** on Christmas Eve to houses all over the world.

1 Draw a circle for Santa's face, and a triangle on top of it for his hat. Draw four lines underneath his face for his beard. To the left of the beard draw a small circle.

5 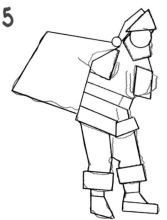 Using your shapes as a guide, outline Santa with softer lines. Round all the sharp corners and make the straight lines a bit wavy. Add extra lines to the arms, belt, coat, and cuffs, as shown.

2 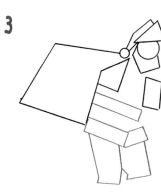 Connect the hat triangle to the small circle with four small lines. Draw a big rectangular shape for his bag and two smaller ones for his cuffs. Draw a triangular shape with the point facing down, as shown.

6 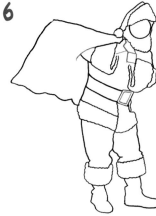 Erase the guidelines and any extra lines. Draw shapes and lines for the hands, as shown. Draw the square in the middle of his belt and add a curved line to his bag.

3 Erase three of the lines drawn in step two as shown. Draw shapes for his belt, the bottom of his coat, and his legs, as shown.

7 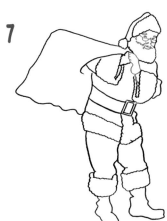 Finish drawing his hands and wrists by softening the lines of the rectangles and adding fingers. Draw his face and eyeglasses. Now erase the inner circle guideline.

4 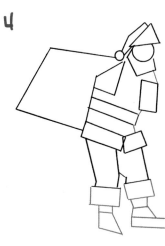 Add lines to connect the shape of the body. Now draw the basic shapes of Santa's pant cuffs and boots.

8 Santa is almost ready to go! Just shade and add presents to his bag, like the teddy bear, and you are all done!

Angels

Christians believe that angels are messengers of God. In the story of Jesus's birth, more than two thousand years ago, angels came to his mother and told her she would give birth to the Son of God. In the story, angels also told **shepherds** about Jesus's birth.

There are many other beliefs about Christmas angels. Children in the country of Hungary believe that angels decorate the Christmas tree and bring them gifts. In some European countries, children write letters to Jesus instead of writing to Santa. They believe that the letters are taken to heaven by angels.

Today angels are symbols of peace. They are used in nativity scenes and on Christmas cards. They also appear as **ornaments**, often atop the Christmas tree!

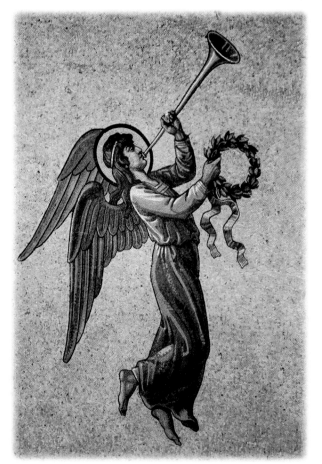

1

Draw two circles for the head and the halo, one inside the other. Draw two triangles. One point of the top triangle is hidden behind the circles. The second triangle overlaps the top one. These will be the wings.

5

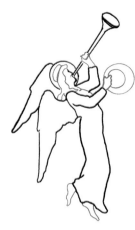

Erase the guidelines. Add a few wavy lines for the hair and the headband. Add two curved lines, one inside the other, for the wreath. Soften the angel's hands and triangular feet.

2

Draw a long, narrow triangle beginning at the inner circle for the horn. Draw an oval on the end of it. Draw four small shapes. These will be the bent arms that hold the horn and the wreath.

6

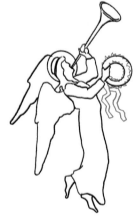

Add curves to the wreath to form the leaves. Add two ribbons at the bottom.

3

To make guidelines for the body, draw three shapes as shown. Draw two small shapes as guides for hands. Draw these lightly. We will erase them later.

7

Erase any extra straight lines. Complete the face by adding the eyes, nose, and mouth. Begin to draw in some wavy lines for the wings' feathers.

4

So far so good! Add triangles for feet. Use the guides to help you shape the body and wings with wavy lines. This will make your angel look natural. Draw the angel's face and horn as shown.

8

Now shade in your angel any way you want! Try to make the wings look like feathers.

The Nutcracker

Long ago, nutcrackers were created to crack open nuts. They were **carved** from wood and then painted. Both useful and colorful, they soon became popular as presents. They reminded people of the **proverb**, "God gives us nuts but we have to crack them ourselves," meaning that nothing in life comes without hard work.

In 1816, a story called "The Nutcracker and the Mouse King" was written by E.T.A. Hoffmann. Later it was turned into a famous ballet called *The Nutcracker*. In the ballet, a little girl, Clara, gets a nutcracker doll for Christmas. She dreams that all of her toys come to life, including her nutcracker, who turns into a prince! The ballet was first danced in December 1892. Watching this ballet has become a family tradition at Christmas. The nutcracker doll is also a special symbol of the Christmas season.

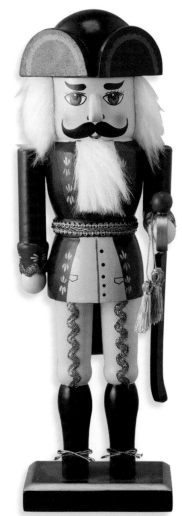

1

Draw a square and three rectangles on top of one another for the nutcracker's body. Notice the sizes. Now draw two rectangles for legs.

2

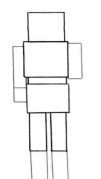

Draw lines on both sides of the body for arms. Draw two more rectangles onto the legs for boots. Draw a rectangle for the base.

3

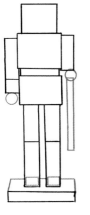

Draw one circle on the bottom of each arm. Draw a long, vertical rectangle at the end of the right circle for his blade. Finish the base and draw rectangles for feet.

4

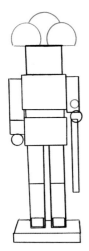

Draw two half circles on top of the square. Draw a curved line on top, connecting the circles. Draw a small circle inside the arm on the right.

5

Following the red marks, draw curved lines to create the handle of the blade. Use the guides to soften and shape the edges of the body and blade. Add lines to the feet as shown.

6

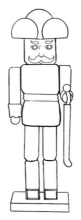

Now erase any extra lines. Add his eyes, eyebrows, eyelashes, mustache, nose, and mouth. Your nutcracker looks great!

7

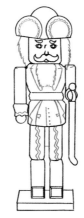

Now outline the head with wavy lines to create hair. Use more wavy lines to draw a beard. Decorate your nutcracker's clothing any way you want!

8

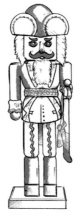

Now finish your nutcracker and shade as shown. Great work!

17

The Christmas Wreath

Its ability to live through winter has made the evergreen tree a symbol of everlasting life. It is also the traditional tree used for Christmas **wreaths**. The circle of the wreath represents God's undying love and the bond of family. It is also seen as a symbol of the strength needed to overcome long, hard winters.

Ancient Romans hung decorative wreaths on their doors as signs of welcome and **victory**. The **Advent** wreath, used in December, had four candles placed around it, which were lit at special times. Many Christians still practice this tradition. The light represents the light that Jesus brought into the world, as well as hope for spring and new light after a long, dark winter.

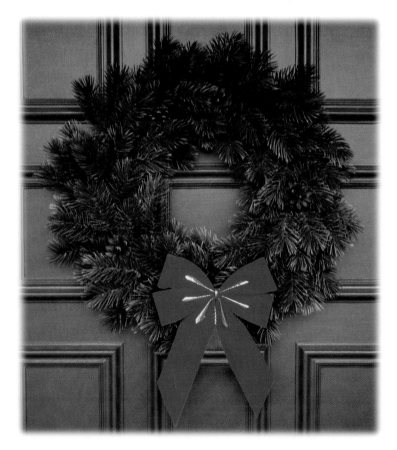

1 Start by drawing two circles, one inside the other. The inner circle should be centered and much smaller than the outer circle.

2 Now draw five small circles within the big circle. These will be guidelines for the pinecones.

3 Draw some shapes to create the rough outline of the bow and the ribbons.

4 Draw V shapes all around the inside of the big circle for the branches. Finish the bow and ribbons as shown.

5 Start adding pine needles to the V shapes with small, straight lines. Shape the pinecones with wavy lines. Erase the circle guidelines for the pinecones.

6 Add as many branches and pine needles as you want to fill up your wreath. Erase both the inner and outer circles once the branches are all drawn.

7 Your wreath looks great! Now add shading to make it look full.

19

The Christmas Tree

It is said that a German man named Martin Luther, who lived in the 1500s, was the first person ever to decorate a Christmas tree. One night he tried to copy the starlight shining through a fir tree by lighting candles he had placed on a tree inside his home. The custom of decorating Christmas trees with candles, apples, and flowers soon spread around the world.

In the 1900s, the fruit and flowers were replaced with ornaments and candy canes. Today families everywhere enjoy buying and decorating their own Christmas trees, marking the start of this joyous holiday season!

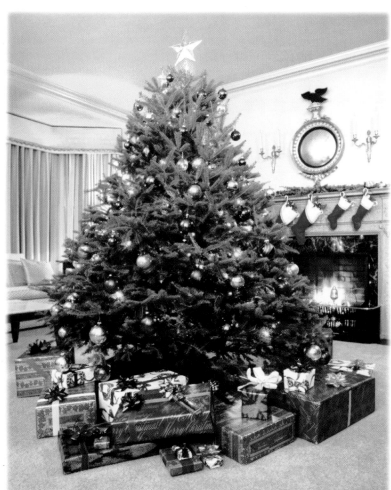

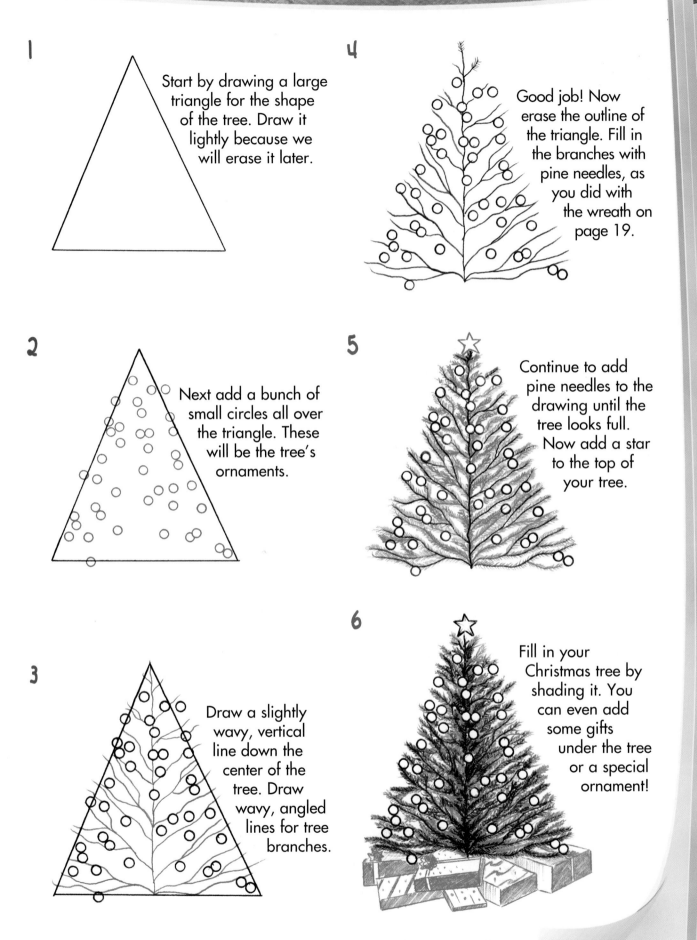

1

Start by drawing a large triangle for the shape of the tree. Draw it lightly because we will erase it later.

2

Next add a bunch of small circles all over the triangle. These will be the tree's ornaments.

3

Draw a slightly wavy, vertical line down the center of the tree. Draw wavy, angled lines for tree branches.

4

Good job! Now erase the outline of the triangle. Fill in the branches with pine needles, as you did with the wreath on page 19.

5

Continue to add pine needles to the drawing until the tree looks full. Now add a star to the top of your tree.

6

Fill in your Christmas tree by shading it. You can even add some gifts under the tree or a special ornament!

Drawing Terms

Here are some words and shapes you will need to draw the Christmas symbols:

circle

cube

curved

oval

rectangle

shading

square

triangle

vertical

wavy

Glossary

Advent (AD-vent) The period of preparation before the Christmas season, which begins in the end of November and lasts until Christmas day.

billion (BIL-yun) One thousand millions.

carved (KARVD) Cut into a shape.

celebration (seh-luh-BRAY-shun) Observance of special times, with activities.

customs (KUS-tumz) Practices common to many people in an area or a social class.

delivers (dih-LIH-verz) Brings something to someone.

dowry (DOW-ree) The money or property that a woman brings to her husband when she marries him.

feast day (FEEST DAY) A church holiday for eating and being merry.

frankincense (FRAN-kin-sens) Dried tree sap used for its sweet smell.

immigrants (IH-muh-grints) People who leave their homes and move to a different country.

legends (LEH-jendz) Stories, passed down through the years, that cannot be proven.

manger (MAYN-jur) An open box used to hold food for animals.

myrrh (MER) A sweet perfume used for medicine and in rituals.

nativity (nuh-TIH-vuh-tee) A scene showing the birth of Jesus Christ.

North Pole (NORTH POHL) The northernmost point on Earth.

ornaments (OR-nuh-ments) Decorations.

proverb (PRAH-verb) A short, well-known saying.

reenact (ree-uh-NAKT) To create something again or to act it out.

religious (ree-LIH-jus) Faithful to a religion and its beliefs.

represented (reh-prih-ZENT-ed) Stood for.

shepherds (SHEH-perdz) People in charge of flocks of sheep.

sleigh (SLAY) A large, horse-drawn cart.

symbols (SIM-bulz) Objects or pictures that stand for something else.

tradition (truh-DIH-shun) A way of doing something that has been passed down over time.

victory (VIK-tuh-ree) The winning of a battle or contest.

widower (WIH-doh-er) A man whose wife has died.

wreaths (REETHZ) Circles of leaves and sometimes flowers woven together.

Index

Web Sites

Due to the changing nature of Internet links, PowerKids Press has developed an online list of Web sites related to the subject of this book. This site is updated regularly. Please use this link to access the list:
www.powerkidslinks.com/kgd/chrisym/